'Tis the Season

Illustrated by
Mary Engelbreit

Andrews and McMeel
A Universal Press Syndicate Company
Kansas City

 is a registered trademark of
Mary Engelbreit Enterprises, Inc.

ISBN: 0-8362-4624-1

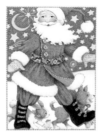

'Tis the Season

'Tis the season
to be jolly—

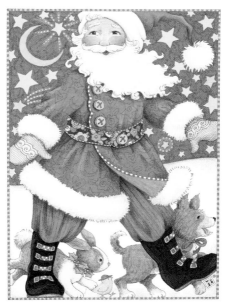

To enjoy the Yuletide gladness…

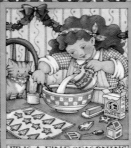

IT IS A FINE SEASONING
FOR JOY ✱ TO THINK
OF THOSE WE LOVE.
— MOLIERE·

...as the time till Christmas morning ticks away...

BELIEVING IS SEEING

…and to take a special pleasure
in the colorful traditions
that make Christmas
such a special holiday!

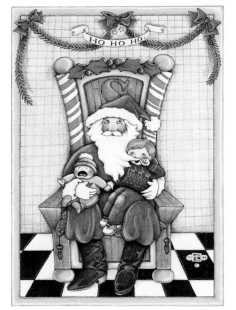

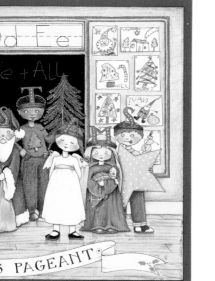

'Tis the season to be jolly
as we shop for perfect presents…

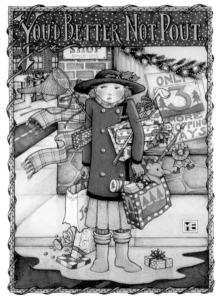

...that we fondly hope
are tailor-made to please...

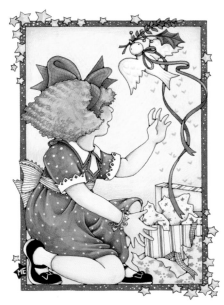

...and to share a cup of eggnog
with our friends
and with our families...

MAY

THE BLESSED LIGHT BE ON YOU,
LIGHT WITHOUT & LIGHT WITHIN.
MAY THE BLESSED SUNLIGHT
SHINE ON YOU & WARM YOUR HEART
UNTIL IT GLOWS LIKE A GREAT FIRE,
SO THAT A STRANGER MAY COME
& WARM HIMSELF AT IT & ALSO
A FRIEND. MAY GOD ALWAYS
BLESS YOU, LOVE YOU, & KEEP YOU

...in the splendor of their
tinsel-tinted trees!

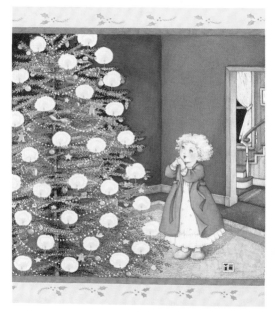

Time to make a list for Santa...

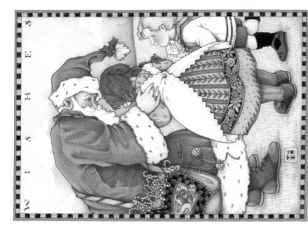

...or to write a nice, long letter...

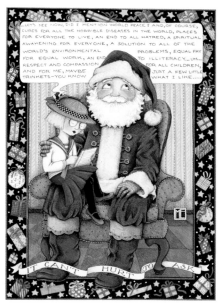

…just to make quite certain
we are understood…

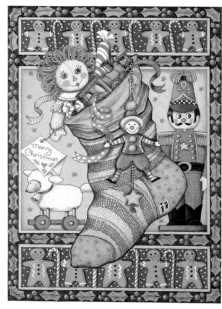

...hoping we'll be down on record
for exemplary behavior,
and we'll soon get our reward
for being good!

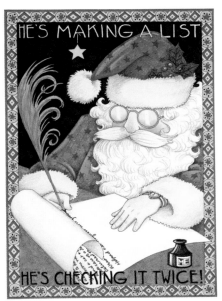

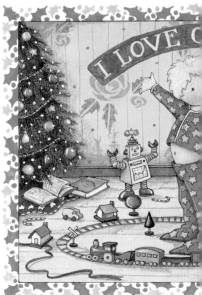

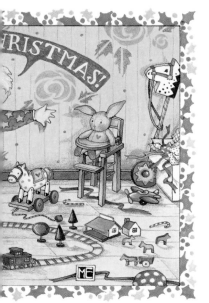

'Tis the time
to be an angel...

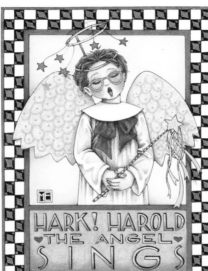

...and to watch for Santa's helpers
as with elfin glee
they scamper to and fro...

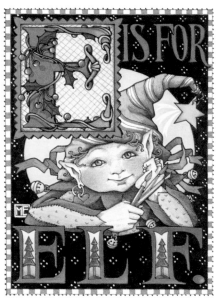

...wrapping last-minute surprises,
helping Santa to prepare for
his exciting midnight journey
through the snow!

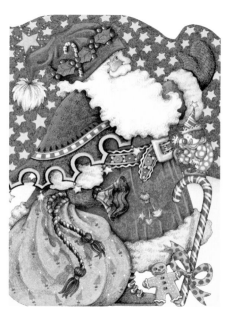

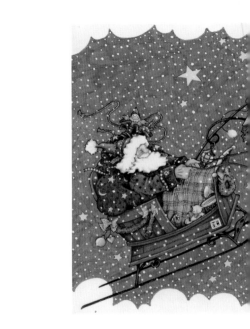

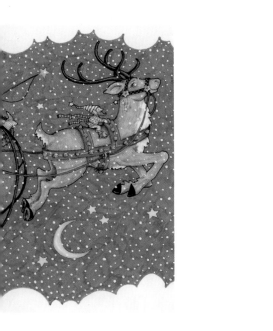

'Tis a time for celebration
in the company of others
and a time for making magic
now and then—

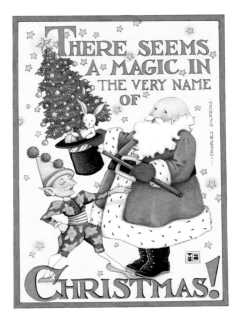

THERE SEEMS A MAGIC IN THE VERY NAME OF

—CHARLES DICKENS.

CHRISTMAS!

'Tis a playful time,
a fun-filled time,
a time of warmth and wonder—

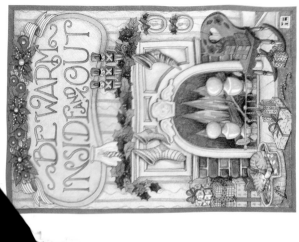

BE WARM INSIDE AND OUT

'Tis the season
once again!